Fun to Draw Mini Mangas

T. Beaudenon

IMPACT
CINCINNATI, OHIO
www.impact-books.com

MINI MANGAS

In the magical world of manga, there are characters, called chibi in Japan. The chibi, or mini manga, is the young version, baby even, of a type of manga hero. They are characterized by a style of anatomy; their heads are as big as their bodies, and their limbs are barely developed.

The mini manga has huge eyes and has very expressive and exaggerated postures, showing what the characters are thinking.

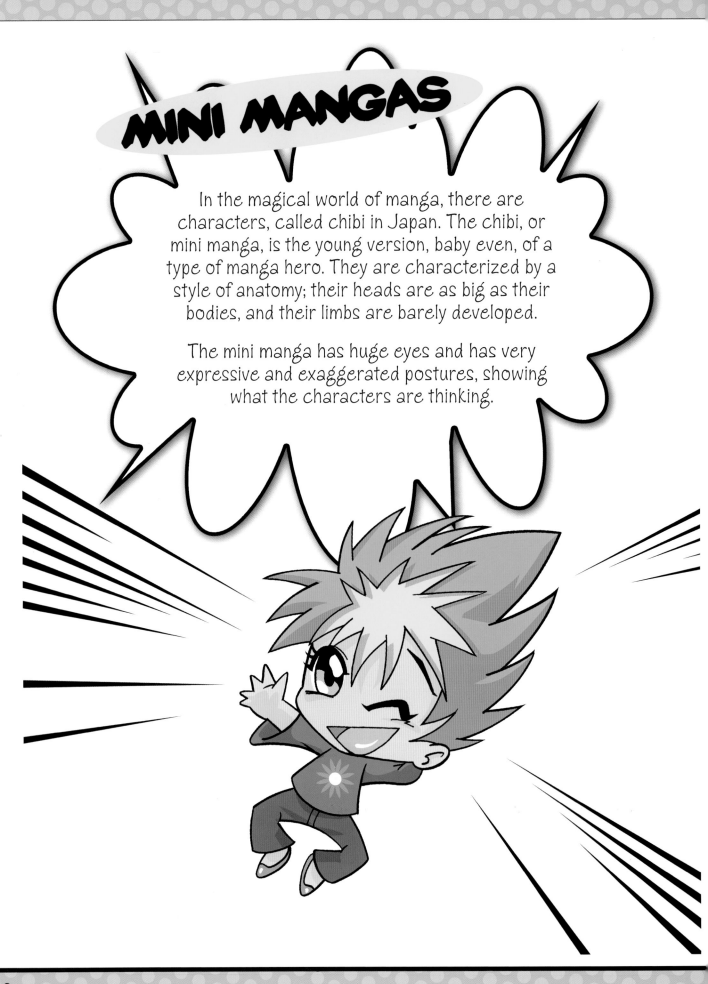

Mini Manga Basics

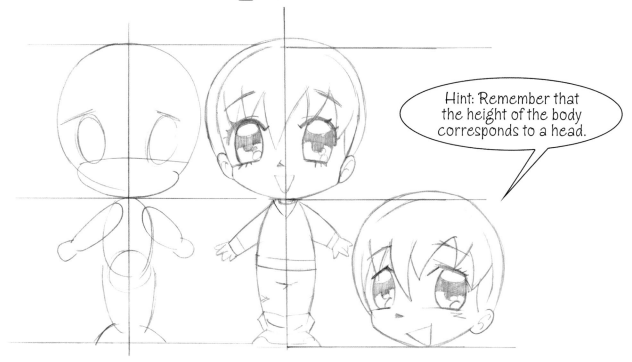

Hint: Remember that the height of the body corresponds to a head.

Proportions

The proportions of a mini manga are simple enough: a large head on a little body. The body is made up of rounded limbs, an essential ingredient.

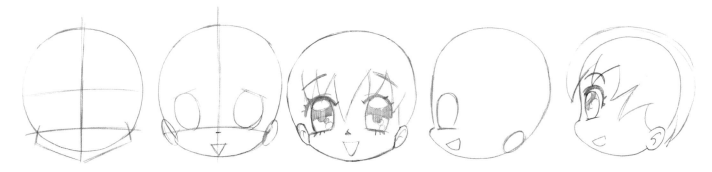

The Face

Begin by drawing a circle, then add an oval shape at the base for the chin. Draw a line about two thirds of the way down, in order to place the two ovals for the eyes. A triangle under the nose represents the mouth.

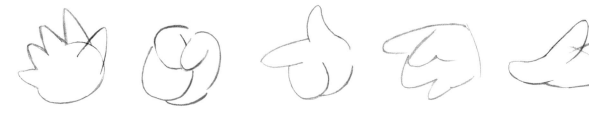

The Hands

Start with a round form, then add fingers in the shape of little round cones. Sometimes join the fingers in the center for a cuter look.

It's Fun (and Easy) to Draw Mini Mangas!

Here is the method that you will find in this book for drawing your characters. Just seven easy steps!

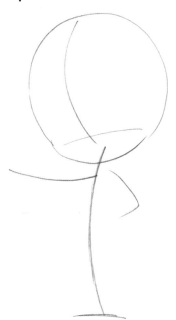

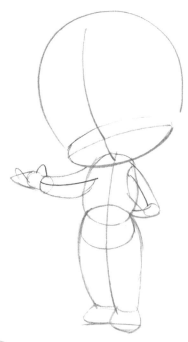

1 Sketch the pose.

2 Add volume.

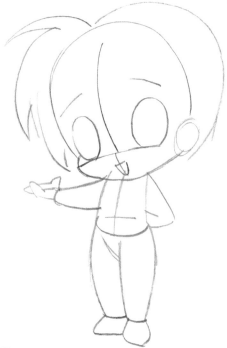

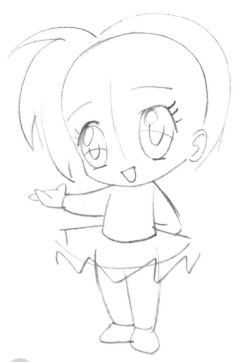

3 Place the eyes and the mouth. Sketch the hair.

4 Add details of the eyes, then outline the clothes.

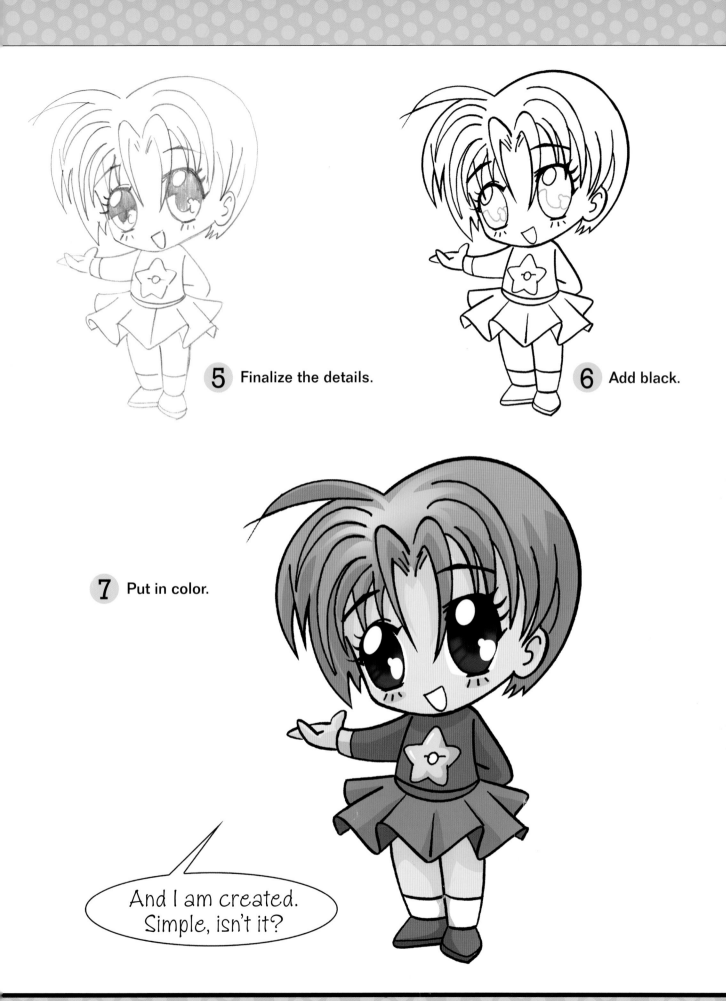

5 Finalize the details.

6 Add black.

7 Put in color.

And I am created. Simple, isn't it?

Cheerful Girl

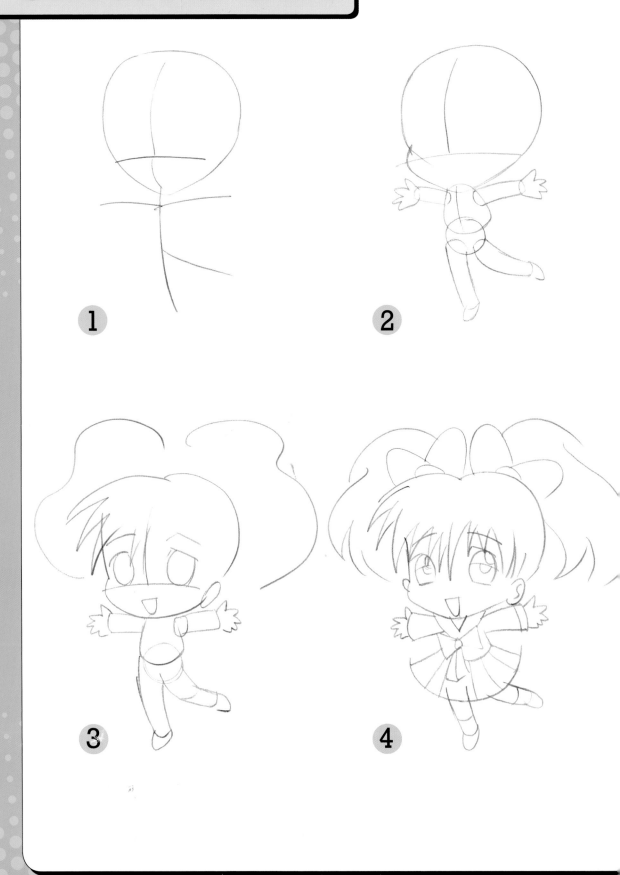

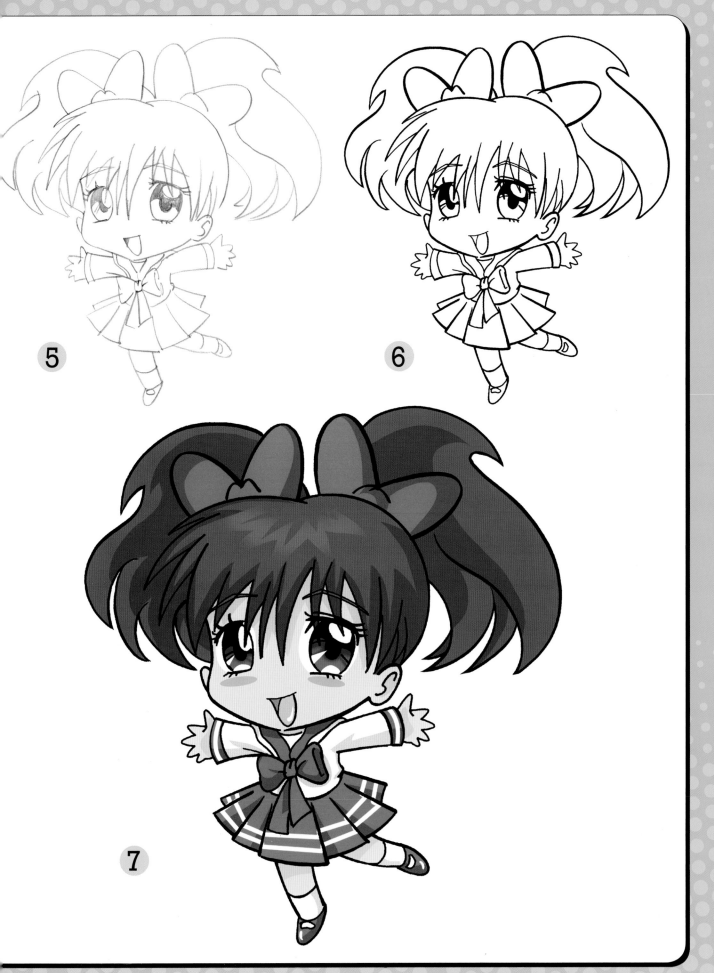

Best Friends

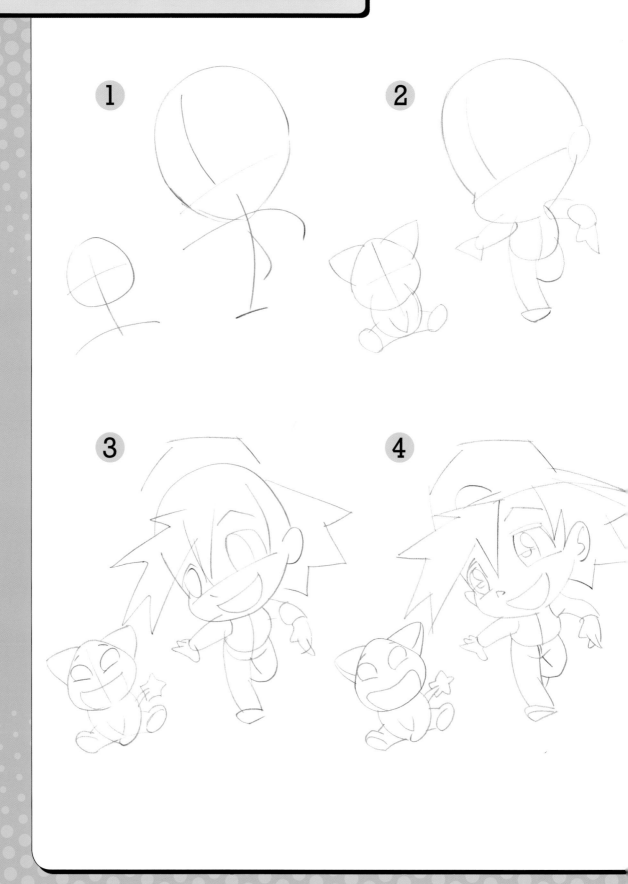

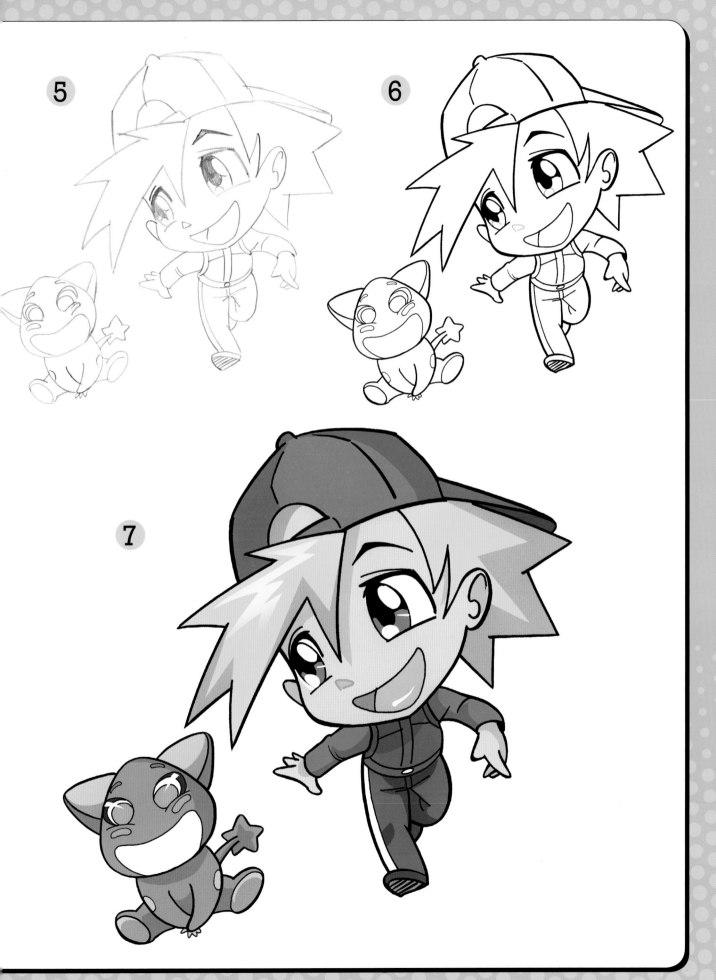

Wind Dancer

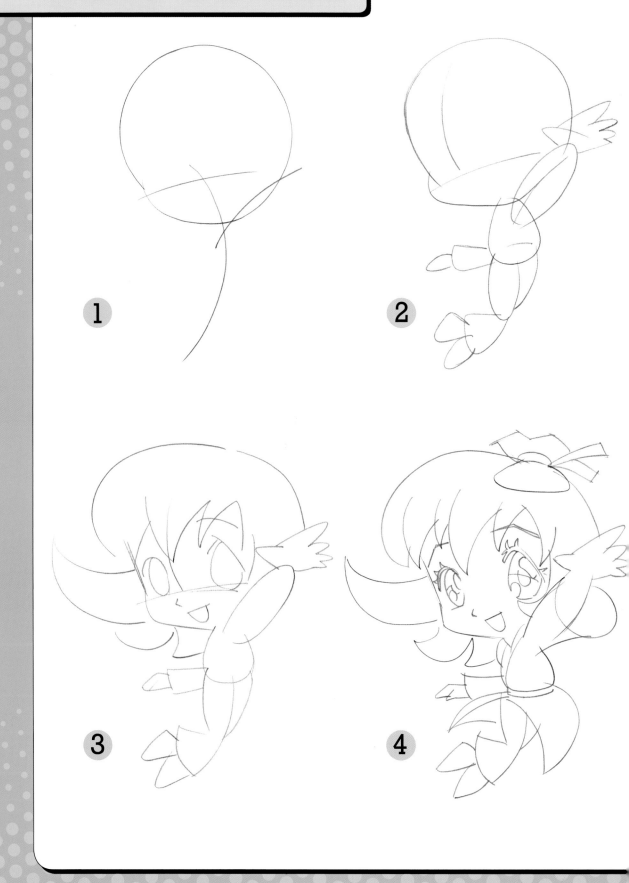

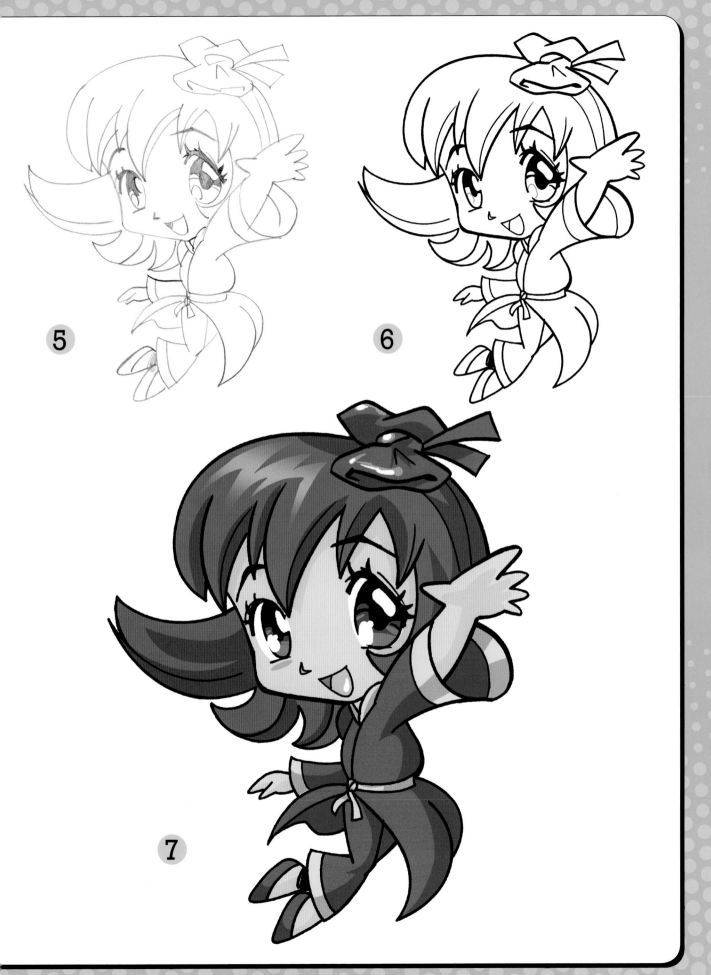

5

6

7

Adventurer

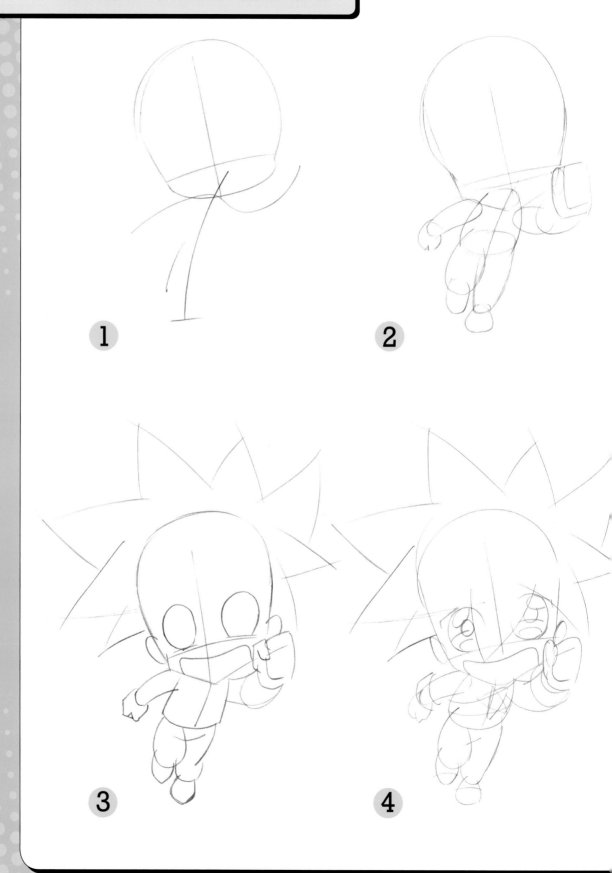

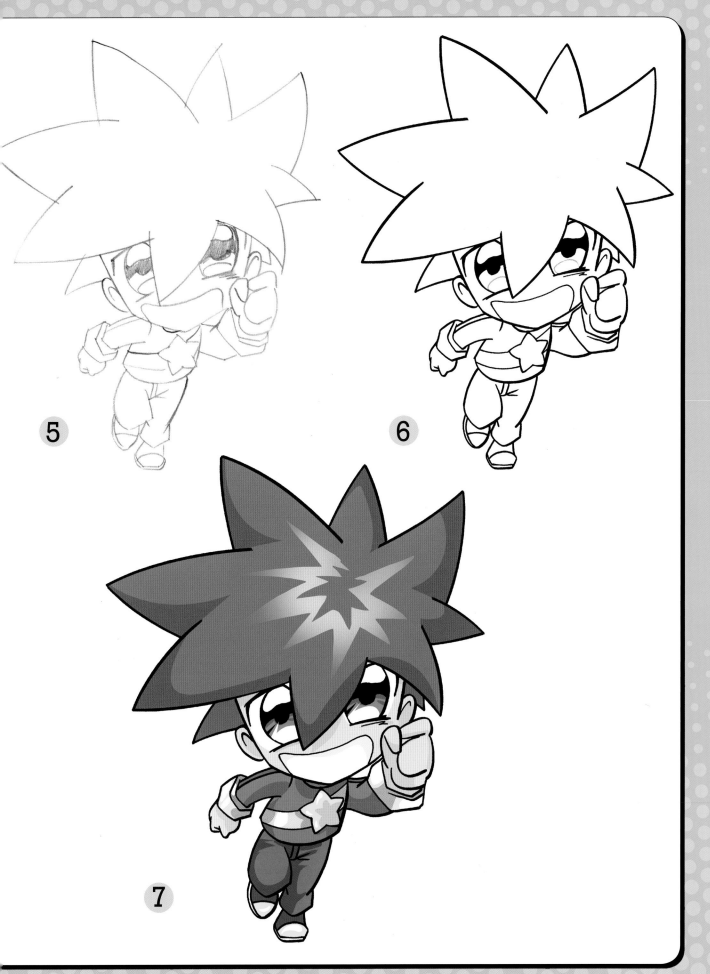

5

6

7

Smart Girl

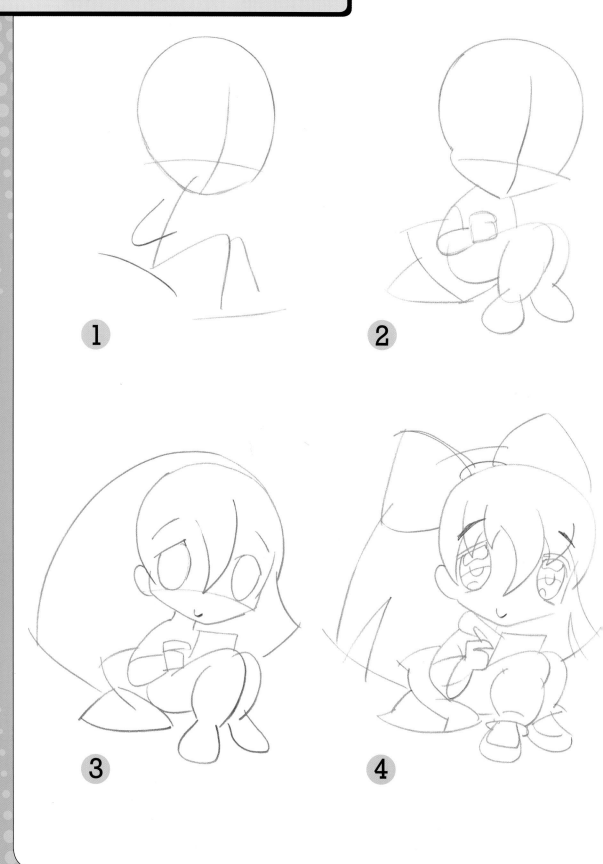

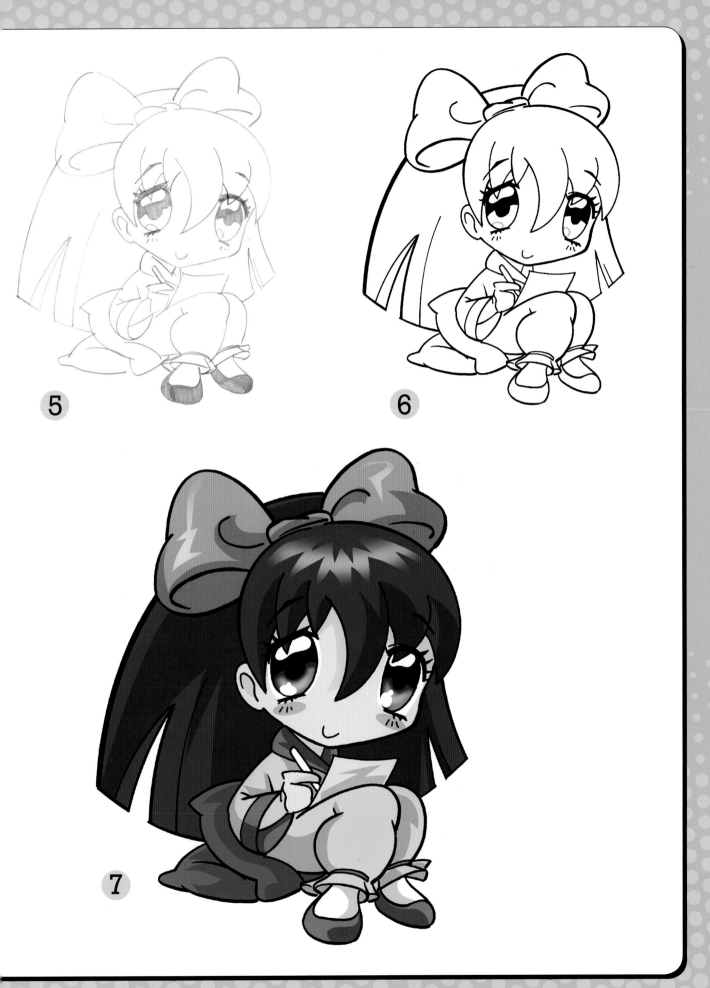

5

6

7

Skateboarder

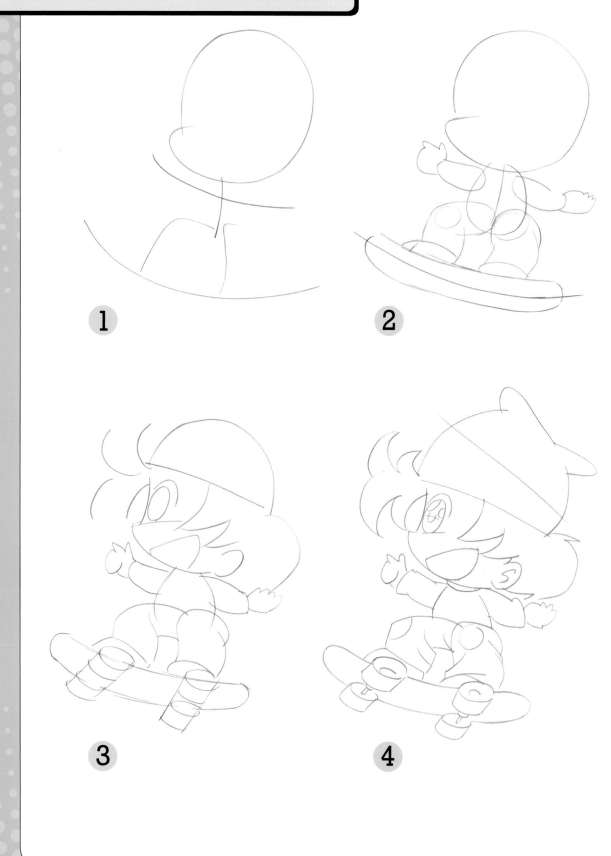

1

2

3

4

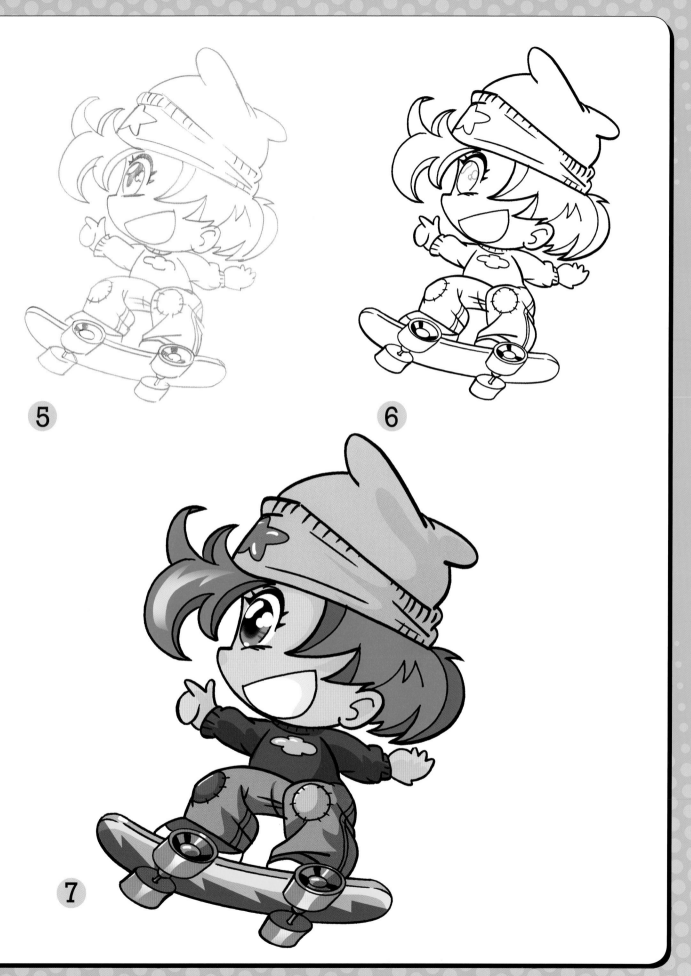

5

6

7

Roller Skater

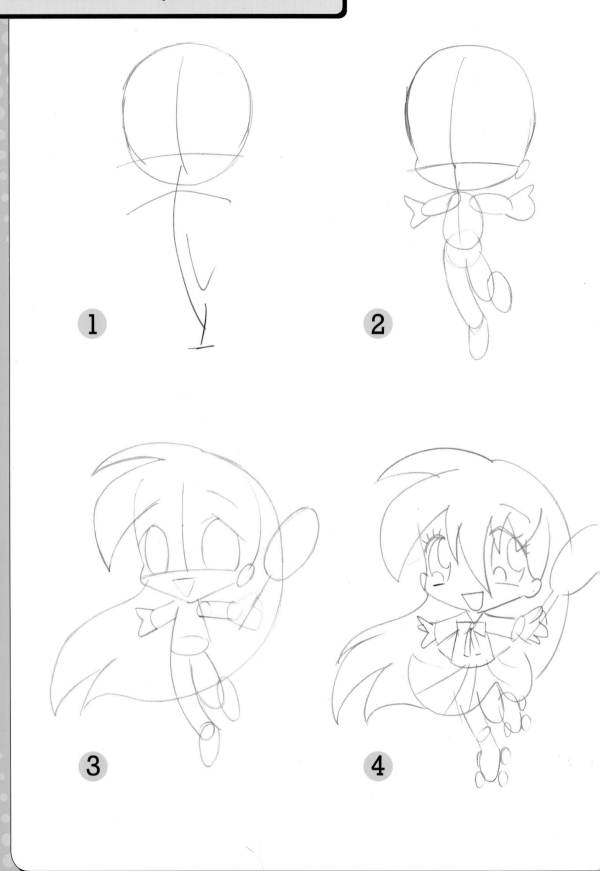

1

2

3

4

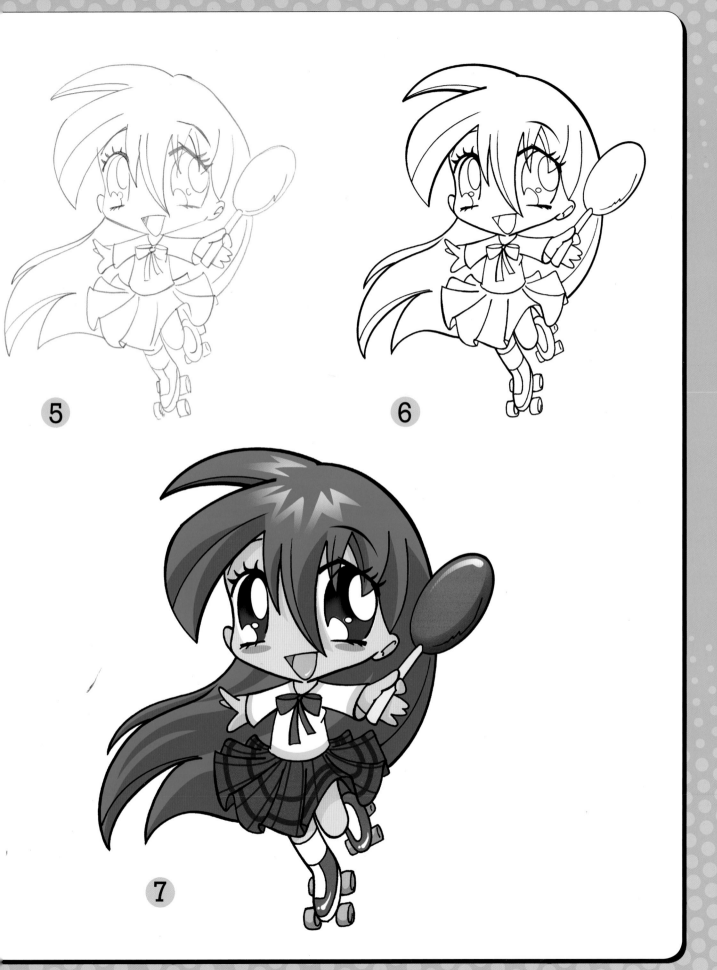

Sled Rider

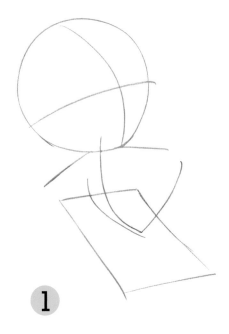

1

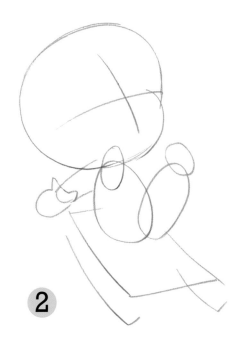

2

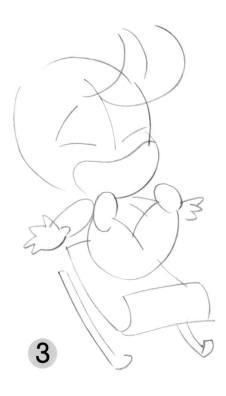

3

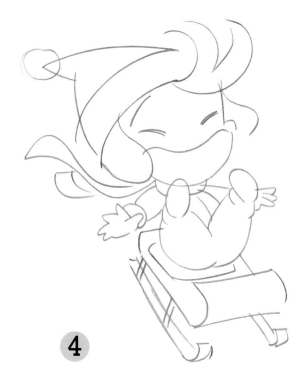

4

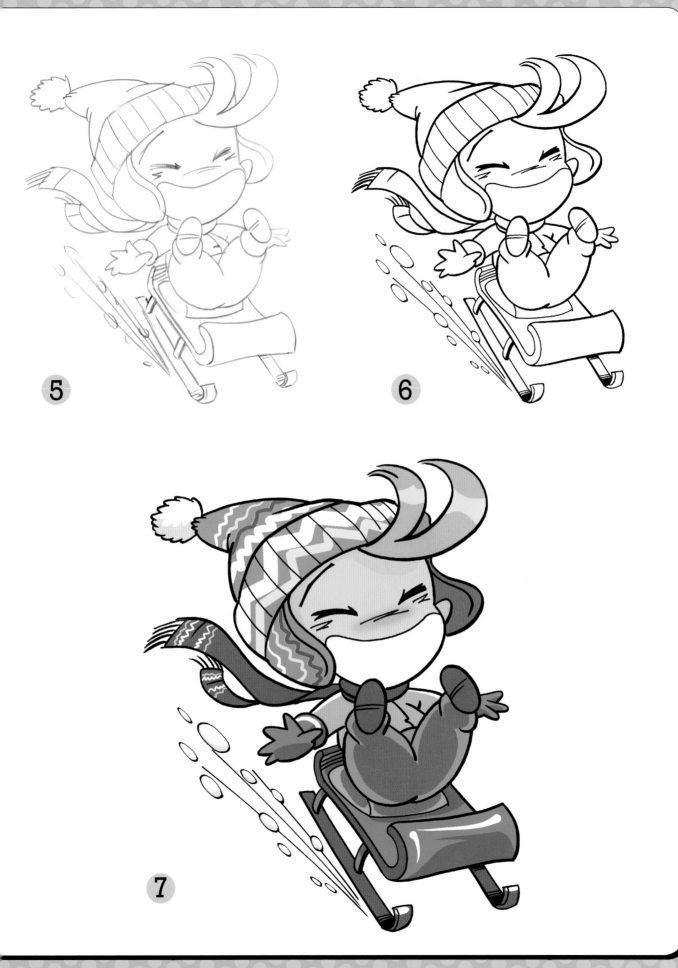

5

6

7

Shy Girl

1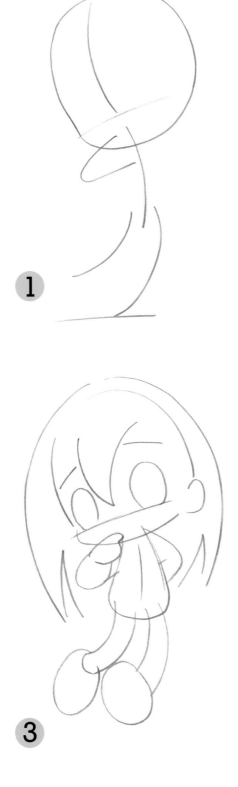

2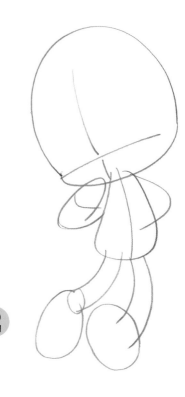

3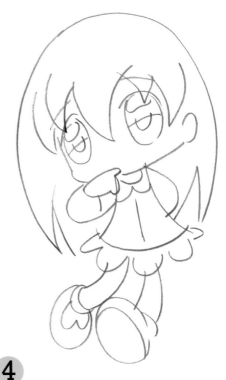

4

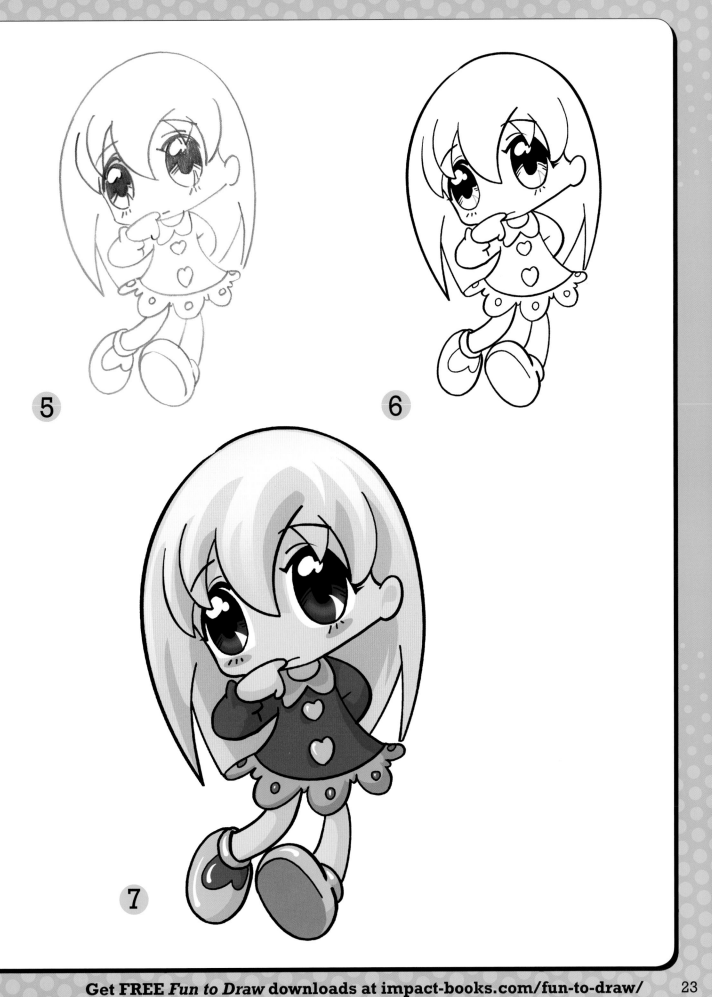

5

6

7

En Garde!

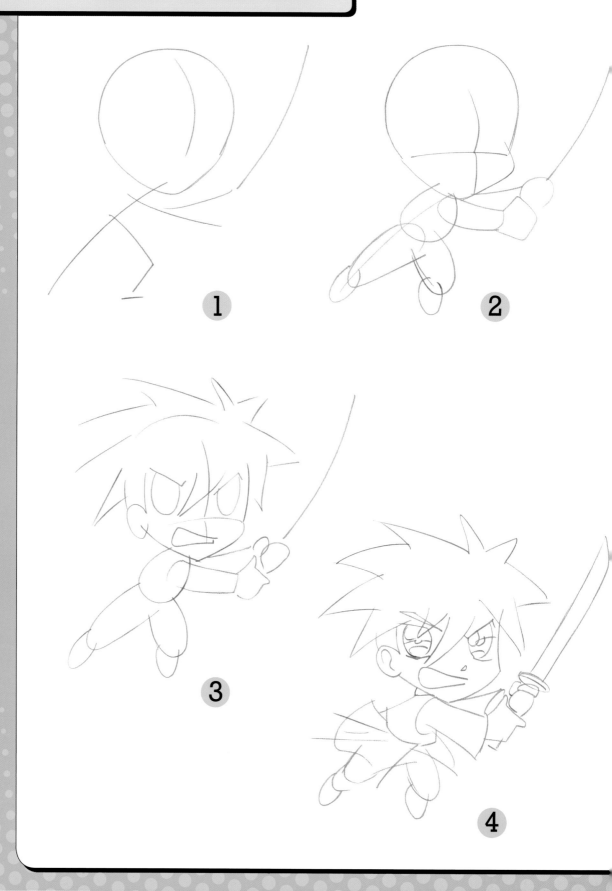

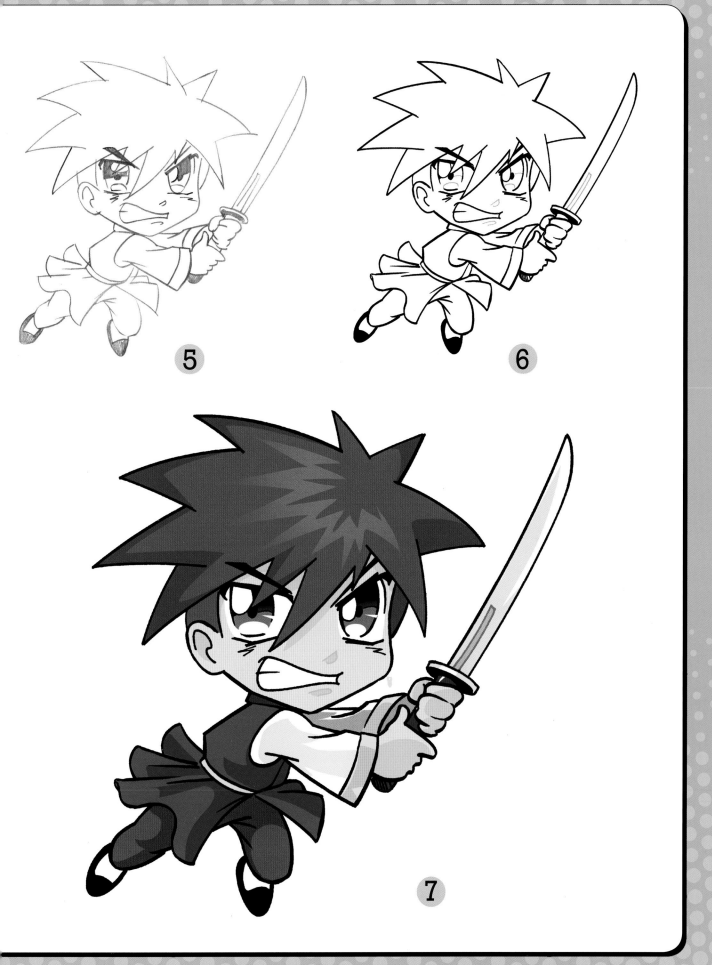

5

6

7

Catgirl

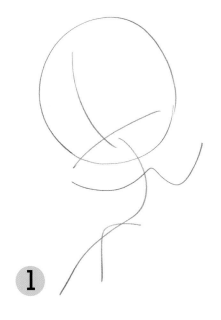

1

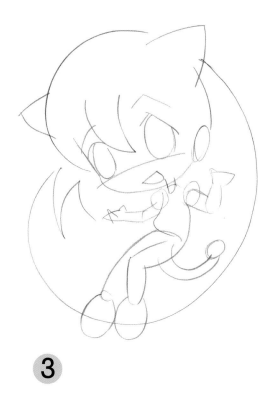

2

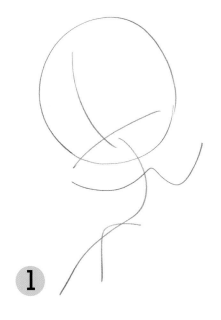

3

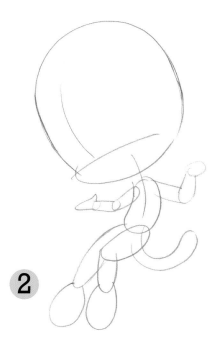

4

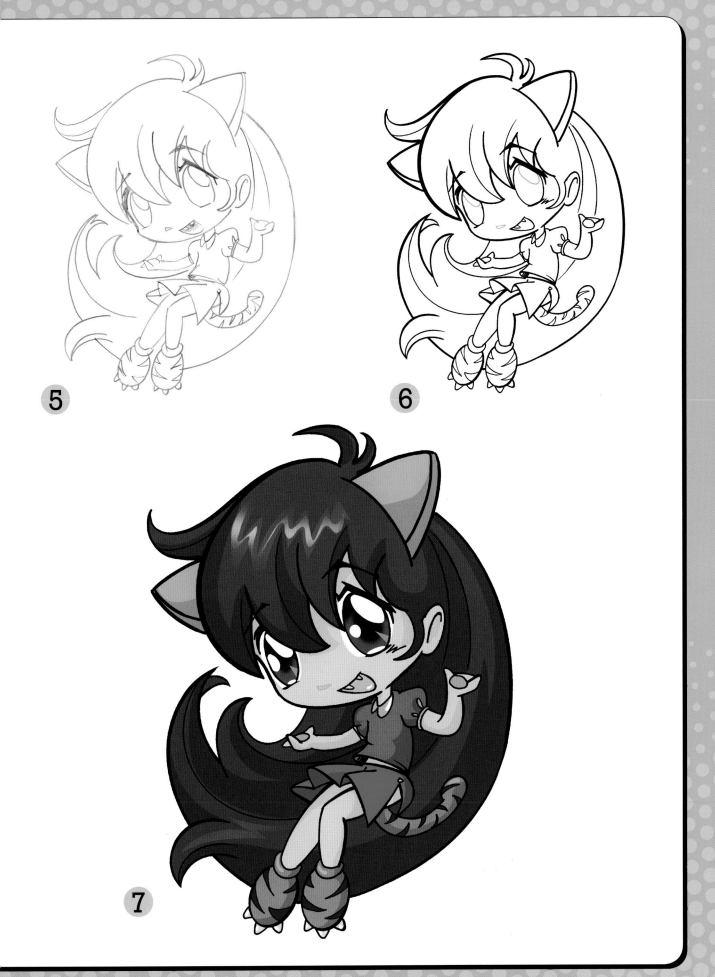

5

6

7

Boxer

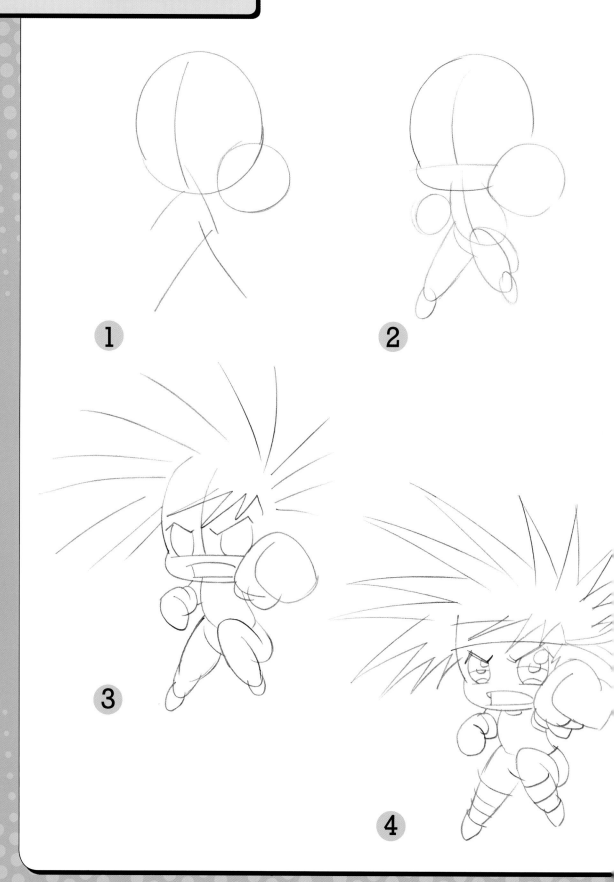

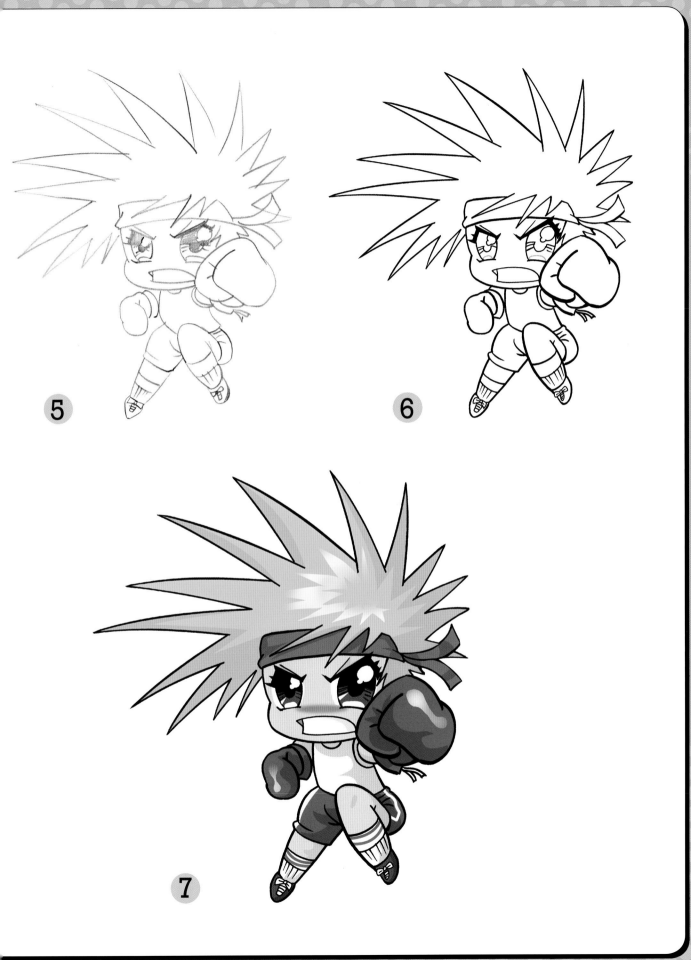

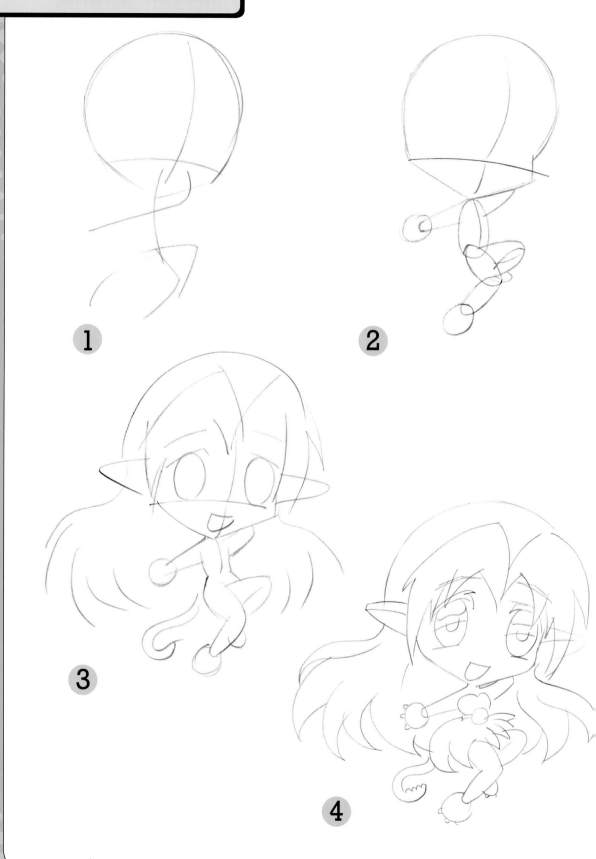

1

2

3

4

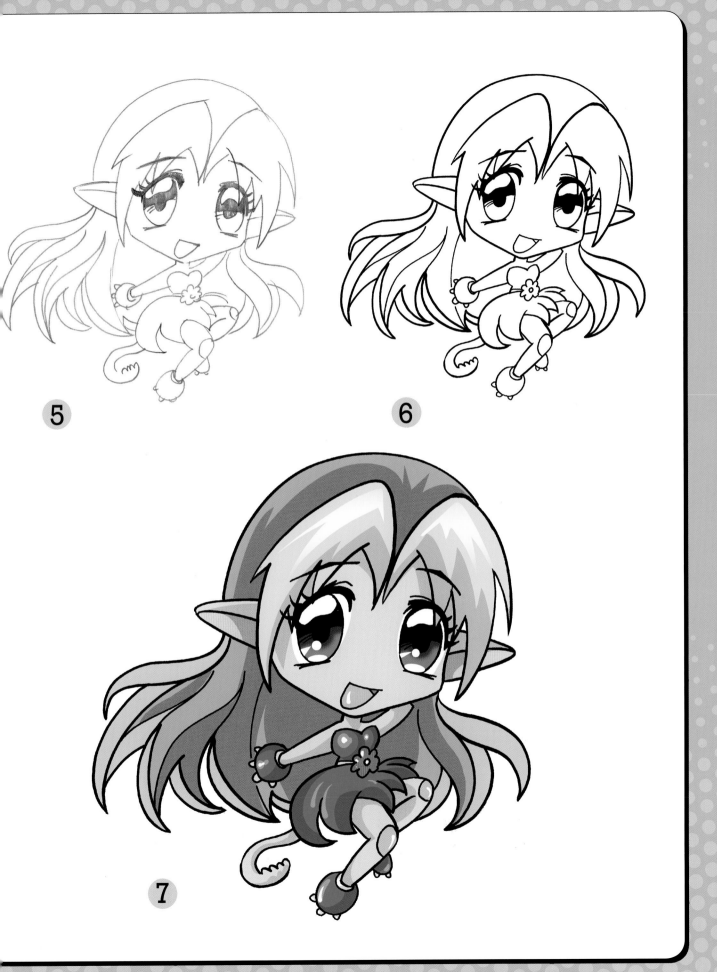

5

6

7

Space Mini

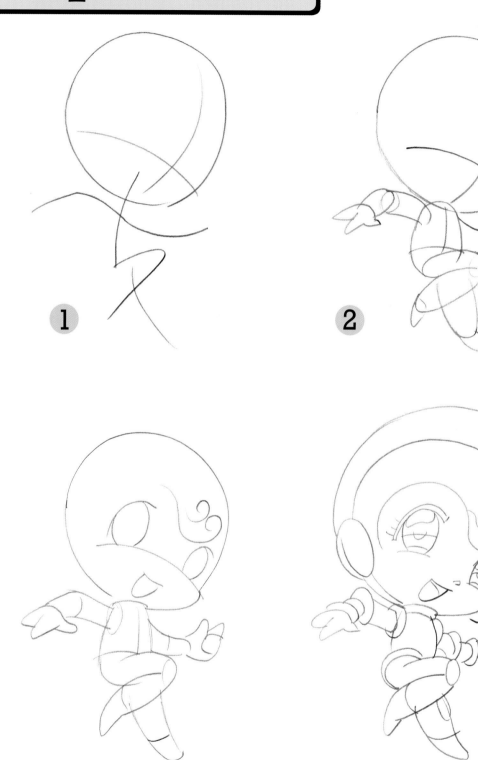

1

2

3

4

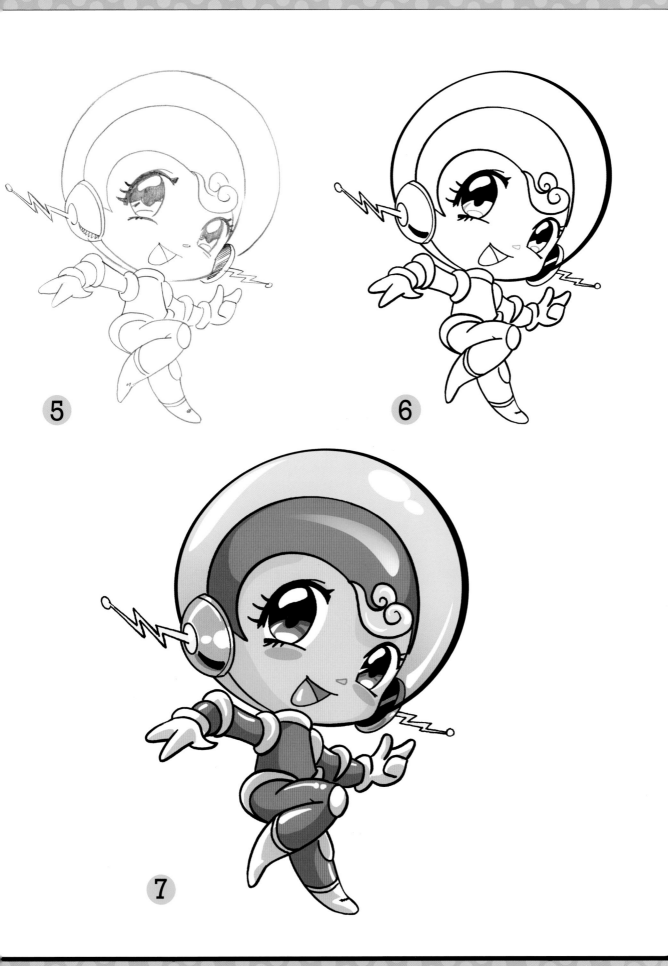

5

6

7

Wood Fairy

1

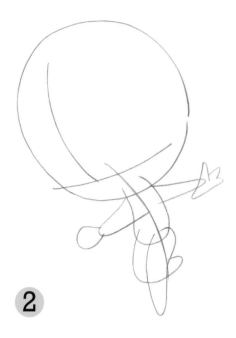

2

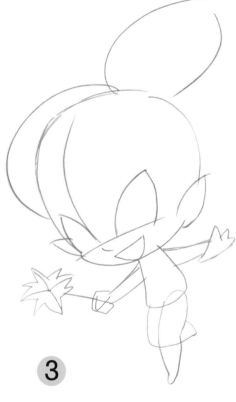

3

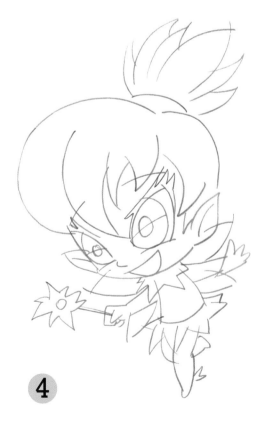

4

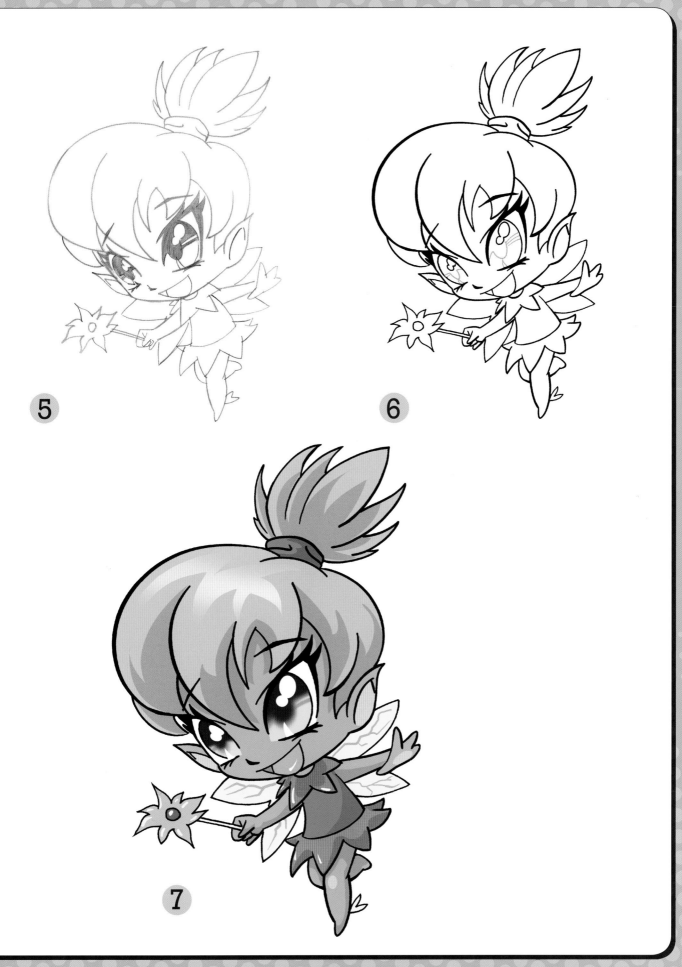

5

6

7

Karate Prince

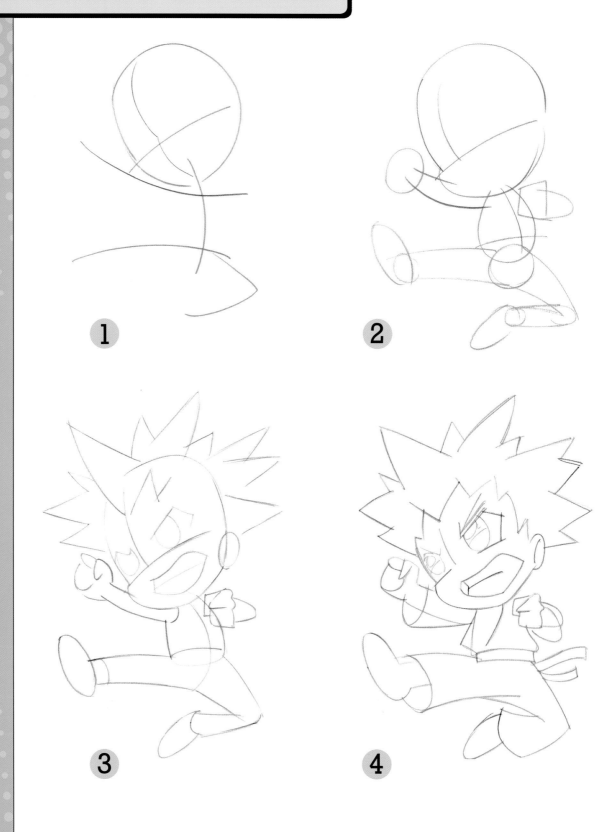

1

2

3

4

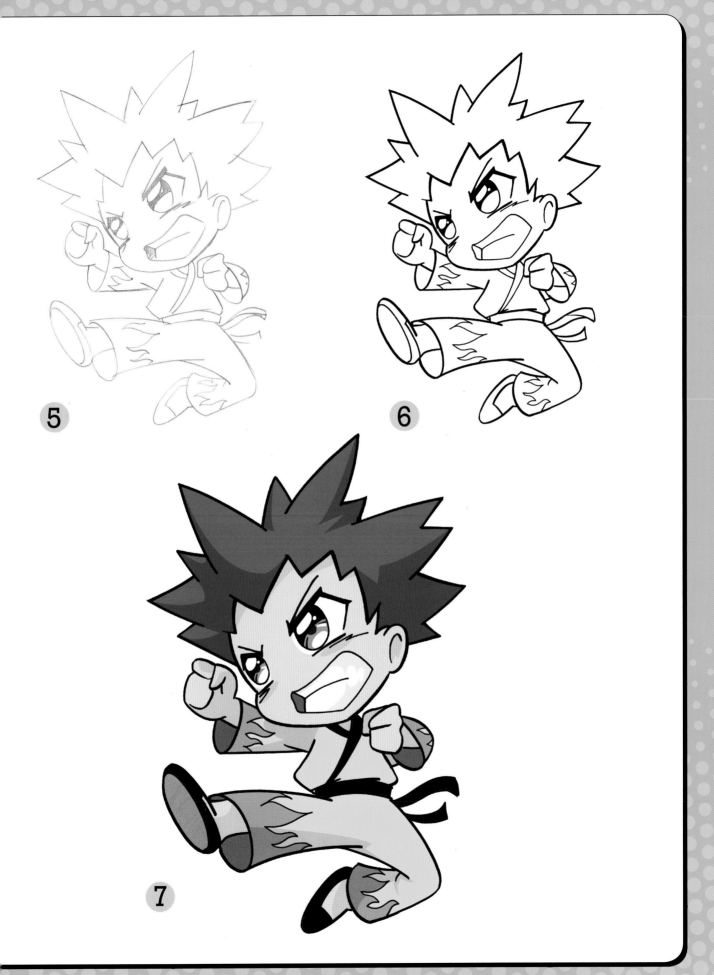

Pirate

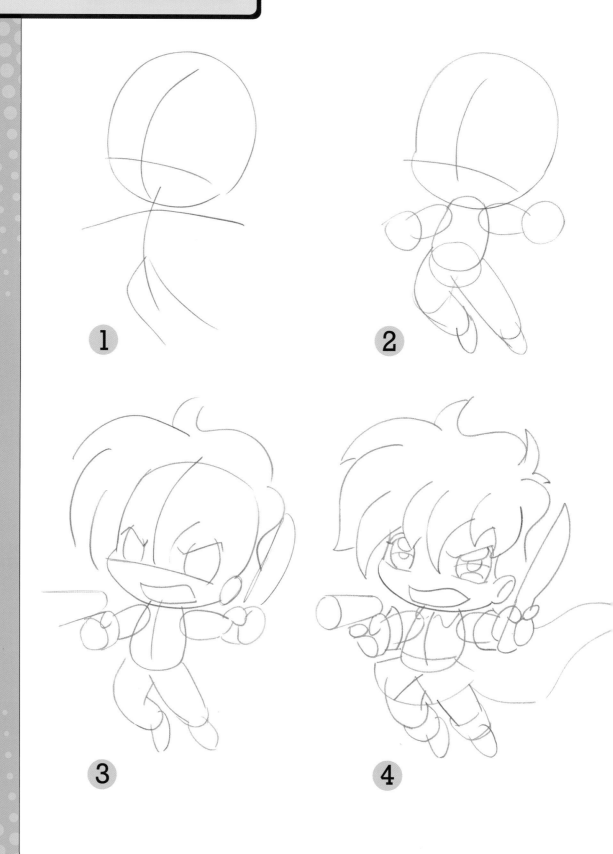

1

2

3

4

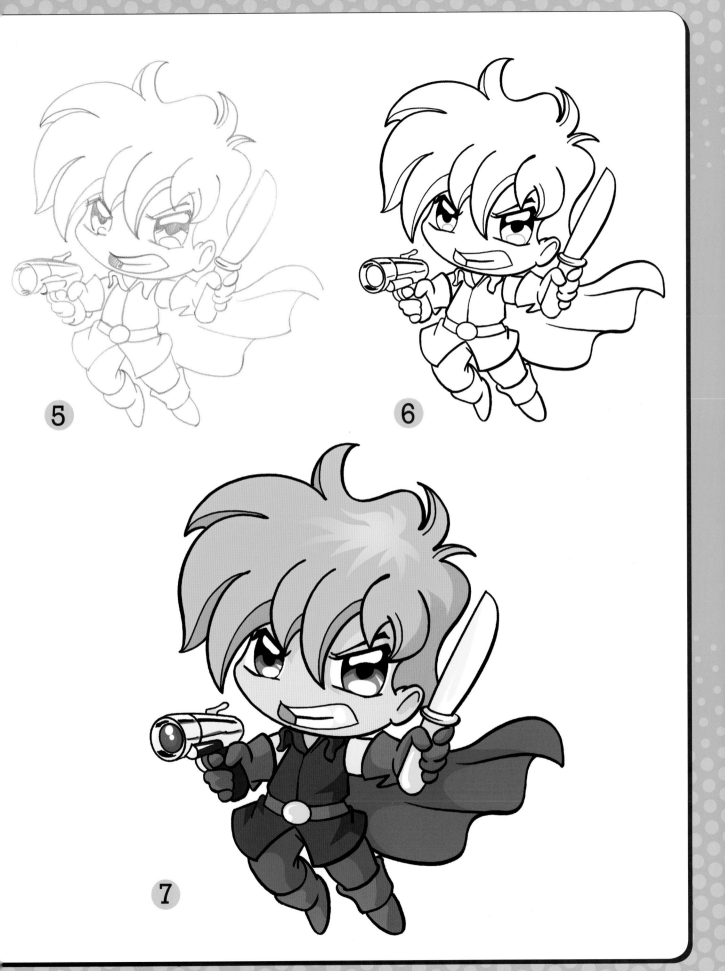

5

6

7

Magician

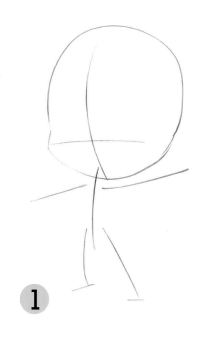

1

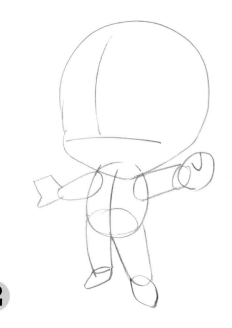

2

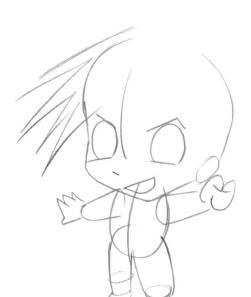

3

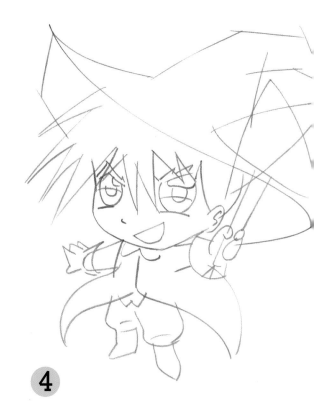

4

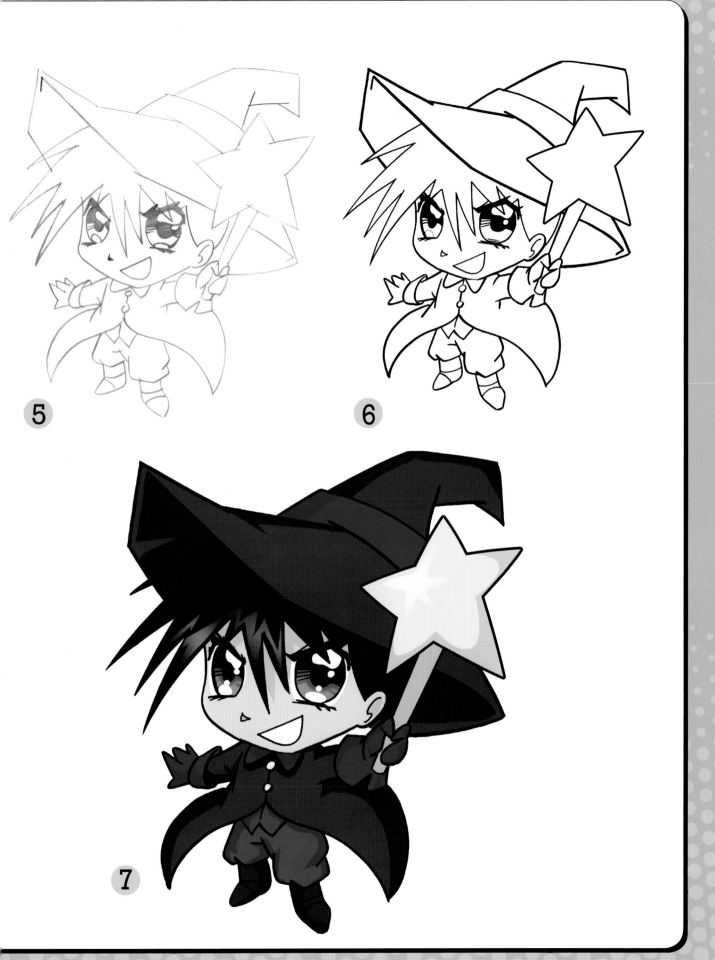

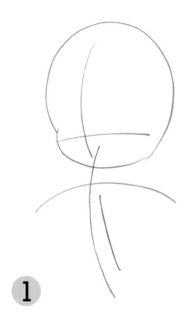

1

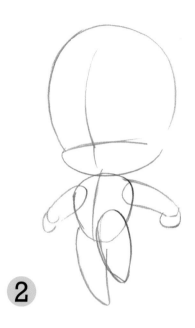

2

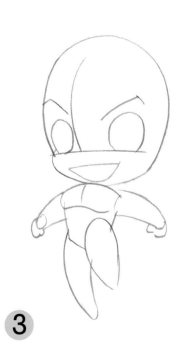

3

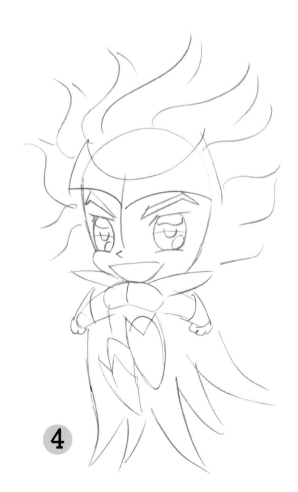

4

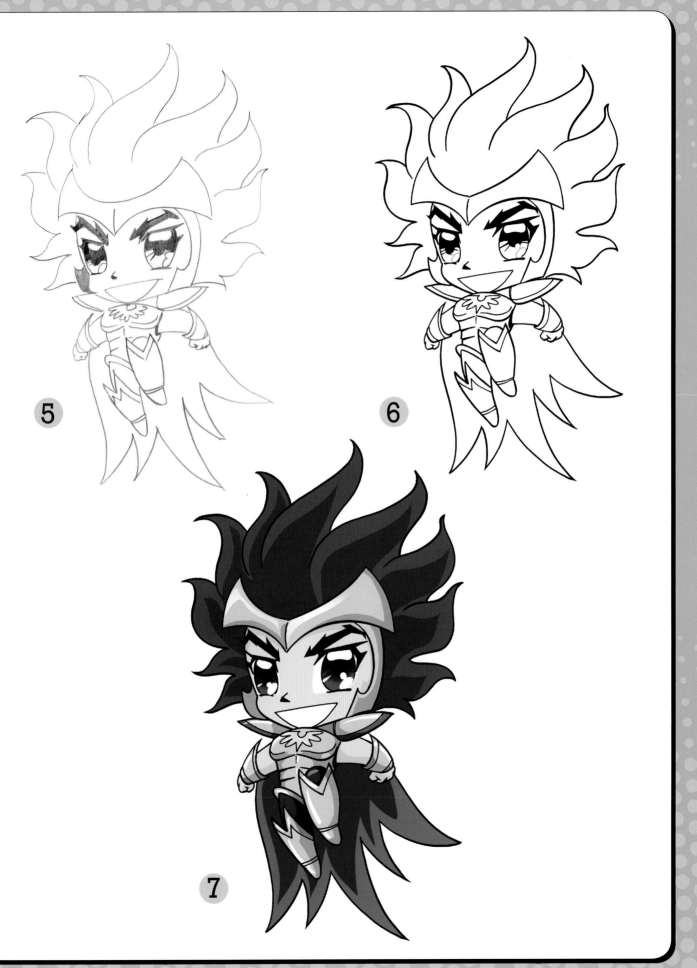

5

6

7

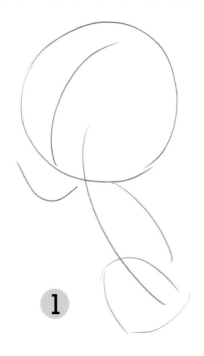

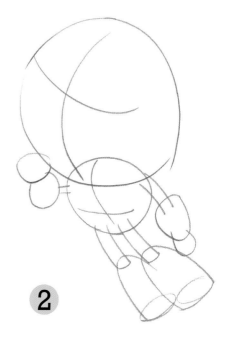

1

2

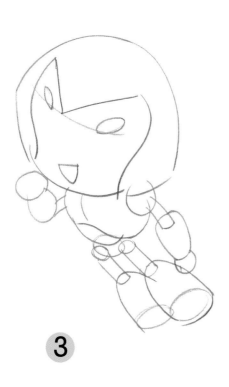

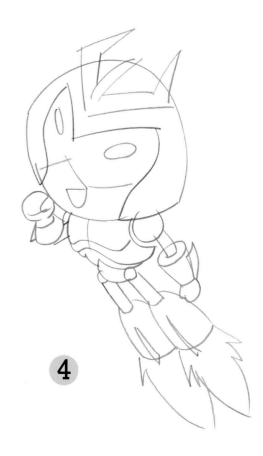

3

4

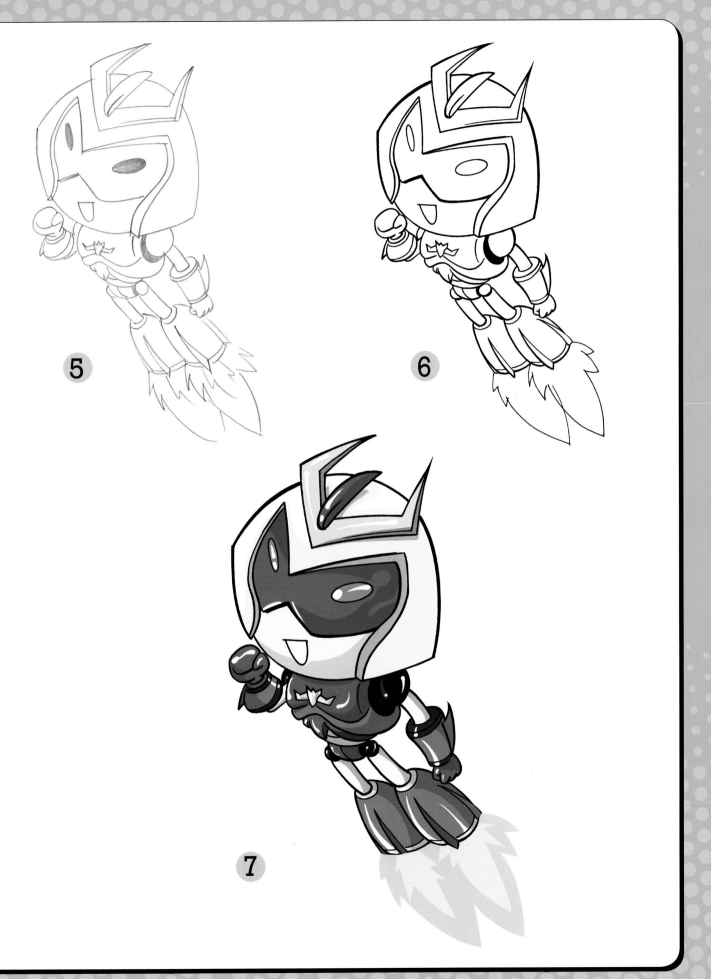

5

6

7

Fun to Draw Mini Mangas. Copyright © 2011 by T. Beaudenon. Manufactured in China. All rights reserved. No part of this book may be reproduced in any form or by any electronic or mechanical means including information storage and retrieval systems without permission in writing from the publisher, except by a reviewer who may quote brief passages in a review. Published by IMPACT Books, an imprint of F+W Media, Inc., 4700 East Galbraith Road, Cincinnati, Ohio, 45236. (800) 289-0963. First Edition.

 Other fine IMPACT Books are available from your favorite bookstore, art supply store or online supplier. Visit our website at fwmedia.com.

15 14 13 12 11 5 4 3 2 1

DISTRIBUTED IN CANADA BY FRASER DIRECT
100 Armstrong Avenue
Georgetown, ON, Canada L7G 5S4
Tel: (905) 877-4411

DISTRIBUTED IN THE U.K. AND EUROPE
BY F&W MEDIA INTERNATIONAL LTD
Brunel House, Forde Close, Newton Abbot, TQ12 4PU, UK
Tel: (+44) 1626 323200, Fax: (+44) 1626 323319
Email: enquiries@fwmedia.com

DISTRIBUTED IN AUSTRALIA BY CAPRICORN LINK
P.O. Box 704, S. Windsor NSW, 2756 Australia
Tel: (02) 4577-3555

ISBN 978-1-4403-1492-6

Cover Designed by Laura Spencer
Production coordinated by Mark Griffin
Originally published in French by Éditions Vigot, Paris, France
under the title: Je dessine deshéros rigolos © Vigot, 2007

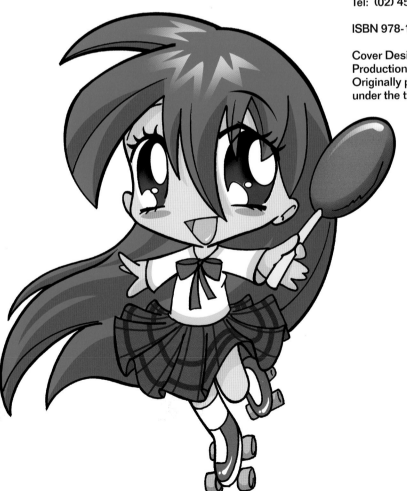

Ideas. Instruction. Inspiration.

These and other fine IMPACT products are available at your local art & craft retailer, bookstore or online supplier. Visit our website at impact-books.com.

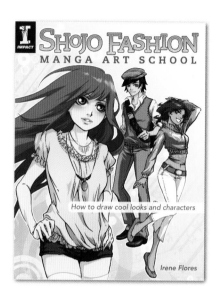

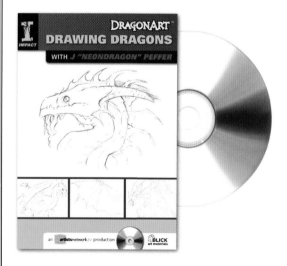

IMPACT-Books.com

- Connect with other artists
- Get the latest in comic, fantasy and sci-fi art
- Special deals on your favorite artists

Follow IMPACT for the latest news and chances to win FREE BOOKS!